Eight Track

EIGHT
TRACK

Oana
Avasilichioaei

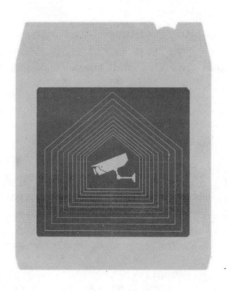

Talonbooks

Talonbooks
9259 Shaughnessy Street, Vancouver, British Columbia, Canada V6P 6R4
talonbooks.com

Talonbooks is located on xʷməθkʷəy̓əm, S̱kwx̱wú7mesh, and səl̓ilwətaʔɬ Lands.

First printing: 2019
Typeset in Optima and Courier
Printed and bound in Canada on 100% post-consumer recycled paper

Interior design by Oana Avasilichioaei
Front and back cover design by Oana Avasilichioaei and Typesmith
Interior photographs, drawing, and montages by Oana Avasilichioaei

Talonbooks acknowledges the financial support of the Canada Council for the Arts, the Government of Canada through the Canada Book Fund, and the Province of British Columbia through the British Columbia Arts Council and the Book Publishing Tax Credit.

Canada Council Conseil des arts
for the Arts du Canada

BRITISH
COLUMBIA

BRITISH COLUMBIA
ARTS COUNCIL
An agency of the Province of British Columbia

Library and Archives Canada Cataloguing in Publication

Title: Eight track : poems and photographs / by Oana Avasilichioaei.
Names: Avasilichioaei, Oana, author.
Identifiers: Canadiana 20190124822 | ISBN 9781772012385 (softcover)
Classification: LCC PS8551.V38 E44 2019 | DDC C811/.6—dc23

for Pam

TRACKLIST

liner notes

track *n.* a section of a phonograph record, cassette tape, compact disc, etc., containing one song, etc.

Voices (remix) Side A

> > one VOICE imagines speaking but chooses to remain silent > > > > > >

in the next room, a VOICE is restless, jittery > > > > > > > > > on the second

floor, a VOICE refuses to get down on all fours while another VOICE drools
with the promise of submission >

> out in the courtyard, a VOICE can be heard proclaiming, attempting to end

the embargo > > > > > > VOICES are given over to VOICES then given over
to covert tunnels, indirect routes, whispered innuendoes, labyrinthine tracks

> > > > > > > > down the hallway, a VOICE lurches in the staccato rhythm
of heels clicking on tiles >

> > > > > > > > > one VOICE denies it all; one VOICE confesses everything;
while the BEDROOM VOICE of another sugar-coats the impasse > > > > > >

If this were theatre, voices would be cells veins cataracts

If this were a symphony, voices would be unwanted intrusions

If this were a meditation, voices would be interior

If this were advertising, voices would compete for who got paid the most

If this were war, voices would be wounded, hard to bear

If this were research, voices would plead the fifth

If this were an inquisition, voices would grow secretive

in the pantry, a VOICE sounds to never be sated > > > > > > > > > > > > > >

the attic hides VOICES starting a revolution or resigning themselves to a night

of board games > > > > > > > > > > > VOICES rise up, get swallowed whole,
then cause indigestion >

> > > > > > > > > > > > > if to recap does not mean to repeat but rather to
understand through synthesis, a VOICE passes over > > > > > > > > > > > >

VOICES are given over to conflicts they refuse to comprehend because that
would deny their pitch and volume >

> arguably,
VOICES have been known to throw tantrums when under too much pressure

> > > > > > > > > > > if to deny a VOICE is to deny existence, a VOICE falters

If this were a demonstration, voices would clamour with one tongue

If this were a vision, voices would speak prophetically about the past

If this were history, some voices would be forgotten ignored rewritten

If this were telepathy, a voice would be mystically multiplied

If this were a melodrama, voices would babble hiccup sob

If this were a circus, voices would show off their plumage then slip out of
someone's grasp

If this were a game, some voices would have difficulty understanding the
concept of sides

> > > > > > if to deny existence is to deny a VOICE, the abyss falters > > >

> > arguably, tantrums have been known to put pressure on VOICES thrown into the void >

> > > > if certain VOICES were given a harp, they would play out of tune or give up the instrument and play with themselves > > > > > > > > > > > >

in the basement, a VOICE resembles a miniature in gouache > > > > > > > >

> the VOICES that used to congregate in the vestibule now spy on their neighbours while sipping macchiatos > > >

backstage, VOICES are null and void >

> > > > no VOICE has dared to enter the crawl space for at least half a century

track *v.* vary in frequency in the same way as another circuit or component, so that the frequency difference between them remains constant

Voices (remix) Side B

> Listen, we either do it my way or …

But wouldn't that be just another form of pornography? > > > > > > > > > >

The azalea's leaves seemed wilted this morning. > > > > > > > > > > > > > >

> Look, this isn't the nineteenth century!

> I'd thought that by becoming an activist (or was it a chemist?) I'd actually be doing something. > > > > > > > > > > >

Would someone please open the window? It's stifling in here. > > > > > > >

So one time, when I was hiking in the woods, I came upon this man sitting on a rock like a Buddha, buck-naked. >

> > > > > > I was going to show you a childhood album, but it seems to have gone missing. >

> First you sauté some garlic, then add a dash of vermouth if you're really looking to impress. > > > > > >

> > > Yes, well no actually, I never met her, though she was much discussed at a party I once attended. >

in the colony they lived with eyes averted, fondled each other blind

reaped vicious

broken bits of speech acts

in the dark swallowed what there was to swallow

it was a kind of exorcism of the senses, of what could be tasted felt realized

in the compound they formed herds or else were herded

no one could tell who the leaders were anymore, who the followers

dichotomies proved useless

some words had lost their meaning, for example, *imagine*

in the cavern they gutted and gorged

even beasts looked upon them with scorn (or was it indifference?)

various versions played out

the innocents were dying in droves

also the culpable

in the street someone yelled for cover

a loud beeping insisted on the right path

but everyone was weary of religious inclinations

in the cellar someone coveted a neighbour's calm eyes and was struck blind

the sky bore a vision

though not of celestial objects

So maybe we should just call it quits. >

> > > > > > > > > > > > > > > > > > > Got a light? It's dangerously dark in here.

> > > > > > Right, so then I say … and then he says … and then I say … and then he says … Isn't that just about the craziest thing you ever heard? > > >

I've got to hand it to you, I just didn't think it was possible. > > > > > > > >

Yeah, so now they've got machines that can sign for you, remember for you, think for you, do your shopping, your laundry, your taxes, your body … > >

> > > > > > Let us, for a moment, consider the matter from a socio-economic perspective. We might ask, who has access? Who is barred from such privileges and by whom? And what might be the repercussions for cultural descendants? >

Mm-hmm, so what happened next? >

She was always such an obedient child. Until she wasn't. > > > > > > > > >

Raise your right hand and repeat after me: I do solemnly swear to tell the truth, the whole … >

though vetoed, the alarm sounded

the tribe was in chaos

at the bottom of the ravine, a border languished

they cried, were denied, then forced to materialize into walls

if they continued to mistrust,

it was a given that they'd be persecuted from all angles

if they insisted on territory,

conflict became ordinary and inevitable.

wounds or solitary misgivings?

in the arena they broke down

beasts of burden

in the dark ferried what there was to ferry

various versions were rejected

liner notes

track *v.* follow the trail or movements of someone (or something), typically in order to find them or note their course

Q & A

What is the terror forming on the street corner?

The glass eye watches, vigilant.

Not to spy, but to monitor.

What do we passage through these facepages?

It was the era of self-surveillance.

It is the era of self-image worship.

When curiously slipping into voyeurism, do even our most impartial kindnesses become performances?

Tell me, are you sovereign, are you willing in a time of wakeful living?

On the streets, under the unseen eye, we walk with eyes averted, sunken into screen's, focused on the ground, on elsewhere, on any time but now.

Where is the slippage? Where, the booming mechanical voice concealed behind the picture frame?

It was the great era of seeing.

It was forgetting where to look. Or how.

A layer, then another layer, then another.

It was the era of a new form of oligarchy.

It is the era of a new form of oligarchy.

What do we passage with our refusal to be implicated?

What is the trauma of this relentless echo?

A layer, then another, then the eye, present and overall ignored.

It is a moment, a choice, then it is gone.

Onwards and onwards.

Or rather, backwards and backwards.

Or rather, simply standing still.

What reflects back to us in this two-way mirror?

The distinction between the watcher and the watched growing ever thinner.

The imitating and the imitated facing each other in one unvarying stance.

What is the tenor of a small act, a sight, a slight shift in the voice's horizon?

We meddle and we meddle.

We hollow and we hollow.

We ricochet off our will to comfort, to distraction.

Tell me, are you vassal, do you fear in the wake of living time?

While we prevaricate, tomorrow knots itself into a tight corner.

While the state may wish to take on the burden of the future, the burden of the present lies resolutely on our shoulders.

While our chroniclers believe they've attained a kind of imperial freedom, the era of algorithmic governance enacts the office of the overseeing eye.

Why do we make light of our autonomy while frittering the impetus away?

Why do we give up responsibility so readily?

Words hewn by a "big-brother" will.

Not to discipline, but to control.

This is how the subject falters, gradually becomes obsolete.

liner notes

tracker *n.* a device that follows and records the movements of someone or something

A Study in Portraiture

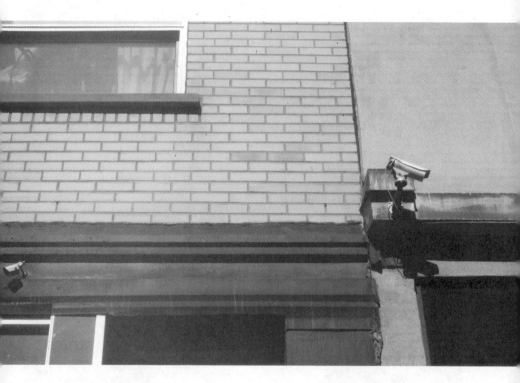

4429 Boulevard Saint-Laurent

4210 Rue de Bullion

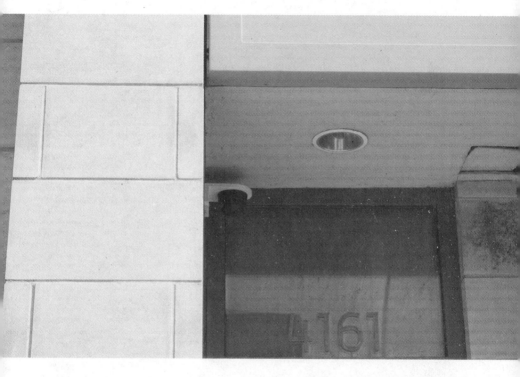

4161 Rue Saint-Denis

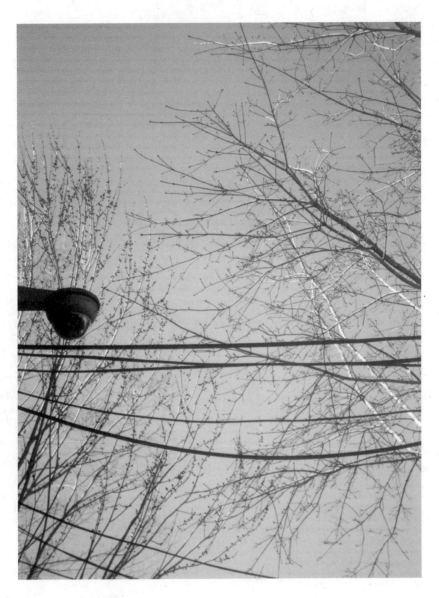

411 Avenue Duluth Est

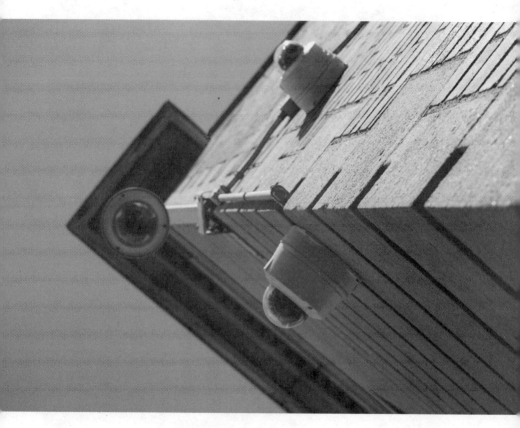

380 Rue Rachel Est

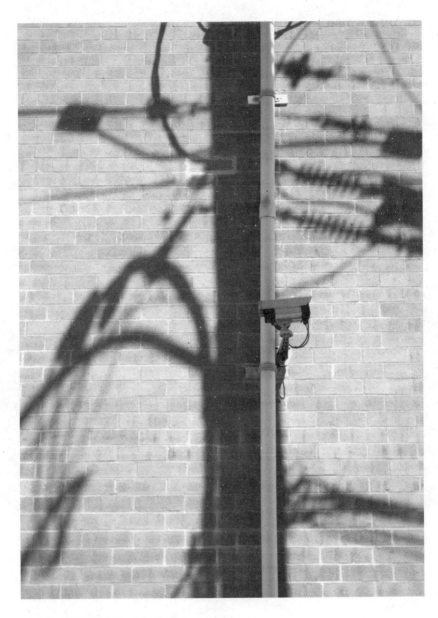

152 Rue Rachel Est (de Bullion side)

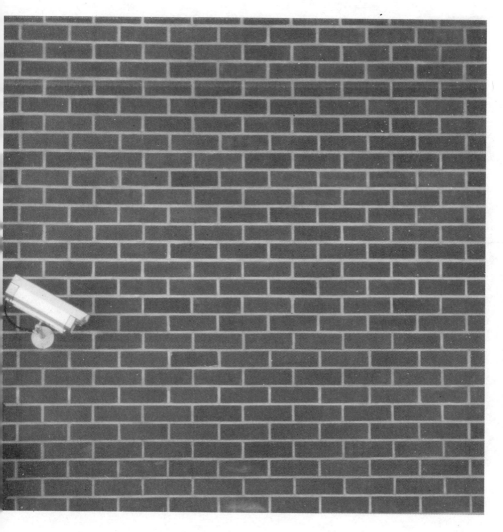

6 Rue Vallières

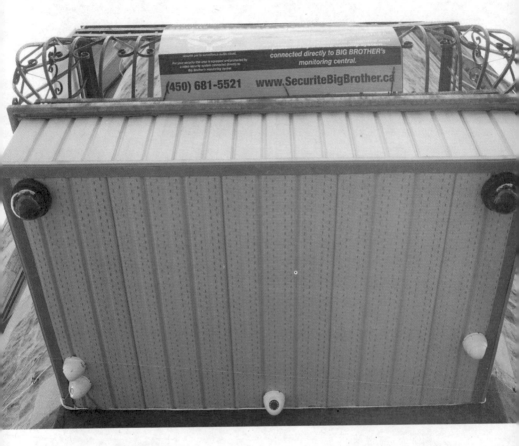

4348 Avenue Coloniale

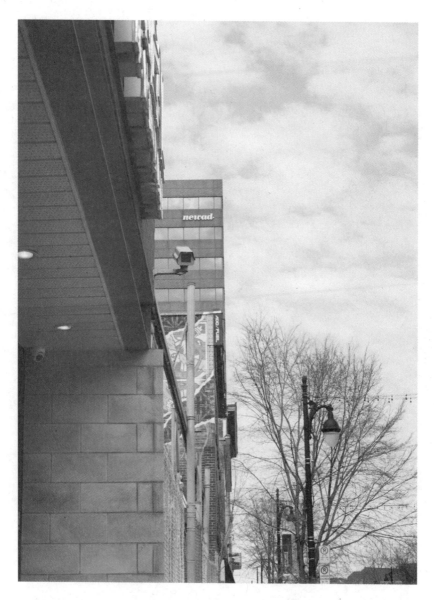

4100 Boulevard Saint-Laurent

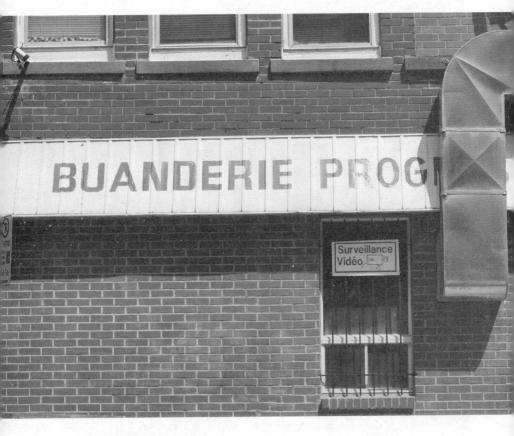

4101–4097 Avenue Coloniale

4420 Rue Saint-Dominique

4238 Boulevard Saint-Laurent

4177–4179 Rue Drolet

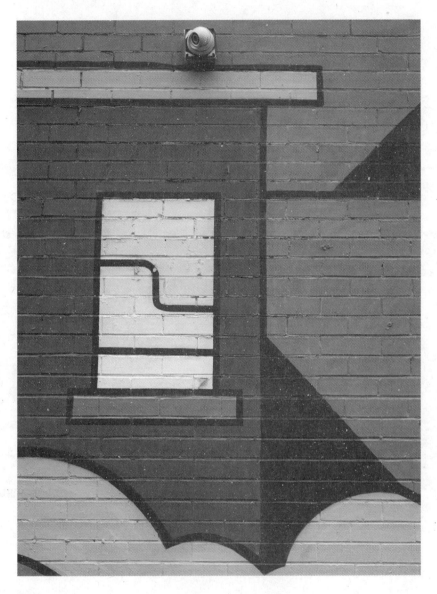

200 Rue Rachel Est (Avenue de l'Hôtel-de-Ville side)

Trackers

SO1: Below decks, I shift, you shift. Concentrate
on the surrounding ocean, its aural fauna

 SO2: Active or passive?

SO1: Both, but differently

 SO2: Ah yes, the sending of sound into the void
that is living and plenty. Listening for a
bounce-back. Or towing a hydrophone,
simply hearing what the ocean tells you

SO1: No matter, the script is predictable

 SO2: It is not spiritual, but for some, possibly an
animal impetus

SO1: Some speak of operations, others of duty,
others still of the aural race for power

 SO2: I am not among them, though I hold the ocean
in acoustic tension, listen for the ping of

SO1: Some speak of concessions, of levelling the
listening field and of so-called enemy sounds

SO2: I do not count among them but I train the sub-
depths in secret warfare, sea to sea, ear to ear

SO1: Some days I sound the alarm and give voice
to my superiors

SO2: Now and then, I translate the echo of a wave
into something menacing or harmless. When
did sound stop being neutral?

SO1: When we became puncture and reflection,
predator and bounty

SO2: How do you bounty?

SO1: I speak the ocean, though it is difficult and
vast, though it shivers the unknown. Some
days, I get lonely. Do you?

SO2: Occasionally, but also active and predatory

SO1: From time to time I am fulfilled. Are you?

 SO2: Perhaps, but also passive, in wait, not quite
 at rest, alert, ready to leap

SO1: If we turn inwards, it is to better acquaint
 ourselves with the custom of the ping

 SO2: Like underwater detectives homing in on that
 one signal

SO1: Yes, but in this living environment, the
 currents are multifold: political and oceanic,
 contextual and acoustic, social and tectonic

 SO2: What drives you to track the ocean's sonic
 movements?

SO1: A naval pat on the back, a bit of glory. You?

 SO2: Recession. Or the promise of red skies at night

SO1: It is a falling into myth, this open jaw, this
 bounce off cliff faces or shoals of fish, a
 moving sub or a sunken ship, a whale or
 some coral, this monitoring of sound

 SO2: Here in the muffled, decelerated abyss, the
 pressure of the elemental is palpable. Also
 within earhearing

SO1: Here we monitor the movement of objects,
 keep a tense aural vigil over the punctuated
 silence

 SO2: A voyage may echolocate for a future war on
 the horizon as listening turns mercenary

SO1: Breathing to monitor inside our metal carcass,
 we puncture the aural fabric of oceans

You admitted that something had to be done. You knew
that action was needed. You stood in a line. Strove to
avoid the traps the pitfalls. You were whimsy for
desire. Feverish for application. You seemed to stand to
attention without standing · to attention. Cautiously
almost imperceptibly you began looking for signs, for
marks. Any trace could be significant or artifact, you
thought. Any marker a ligature between story and
accident.

You were singular but perhaps not alone. Singular in
an assemblage of singulars. You signed. With your
own particles molecules breath. Until you became
the story inside the story. The account inside
the narrative. Accountable to. An abandoned
signature.

In the rock the outrage lay deep. In the strata the frozen
hurricanes of bio matter. Your throat a sudden
gorge. Profound abyssal. Function displaced
by. You intended to keep going but then
stumbled. · Fracturing a concept as you let yourself go.
Using it to break your fall. The boundary between the

container and the contained sometimes so fragile so
flimsy. The membrane allowing the permeating in
the spilling out.

You seemed to stand your ground even when
the ground was soft and questionable. You were
transience itself. A wayfarer. You thought nothing of
leaping into the most contentious charts. Such was your
duty you thought. All dark humour and sinewy
muscle all grit and resilience you were. You
questioned the consensus while mapping
the consensus. Risking discomfort unease. You didn't
mind some discernment. In fact you sought it out.
Opacity of. The audible in the inaudible. Stretched
in between was your realm.

You marked the downfall by how you squandered
language numbers. Then swore you never would again.
The beeches and the poplars were melodic rescuers
you believed. The blinding sheet white of the water.

You inhabited a certain periphery you liked to think.
Acted on the outskirts of the congregation. Listened
for the static beneath the surface sought to bring it
out. Dimensions scattered and coalesced.
Reassembled and disbanded. A thickening on your
palette as you scanned traced. Once you had been
outlaw. Unfactual unverified. Radiating directions
that possibly led to nowhere and which in arriving
became somewhere.

You knew your smallness was profound elemental. The
universe so vast it escaped. Though cellular you
agitated. Tried to do your. Molecule by molecule the
universe needed motion. Stasis meant death absence
of life. Though infinitesimal you had responsibility. Just
like any other. So you carried on.

To call your peg and rope geometry rudimentary or
revolutionary was always a matter of perspective.
Theodolite in hand you thought yourself a kind of
pioneer. You beat the angles into bounds marked out
grids of square footage. Until triangulation changed
how efficiently raw earth could be turned into land that

is owned and governed. The cold burn of metal on
a living membrane. In your wake canals roads and rails
followed. You a shape-shifter a measuring eye
drawing out the paths of others.

Witnessed angled measured marked claimed.
Such was the series of your actions. Repeated over
and over again. Over days months centuries.

The Radar Operator

exist as history only a blip in time

now obsolete

a dangerous blip

ricochet of approaching violence

to war or instigate or suffer in the long hours

of silence

the lode of seeing a heavy burden

now deserted now sparked into obedience

the flash of the signal spinning round

and round

creatured presence or mechanical tension

manufactured e c ho l o ca t ion

The subject is vantage point. The subject is occurrence. The subject is the eye that brutes the sky. The malleable hand that blots out the living. The subject is perpetual, replaceable. An operator, not an operative, with future blood on the hands.

The subject, for the most part, sits. Now and then, the subject stands, stretches the neck, loosens the shoulders, takes a few turns about the room, sits back down at the console. The hands need to be kept busy. With the buttons, the keys, the switches. Eyes searching, staring. Pupils reflecting a convex screen, the bluish-white light of data.

The subject keeps vigil over deviation. Watches over the dead-to-be. It is a laborious becoming, disembodied, out of time, almost in slow motion, followed by rapid firing.

Sometimes, the subject chews gum. A permitted luxury. Or dons a pair of wireless earbuds beneath the standard headphones, zones out to Metallica or Slayer for a few indulgent minutes. Tolerated, though against regulations. A small infraction to make the interminable bearable.

The subject subjects to tedium in twelve-hour shifts. The subject sits in tedium, stares at tedium. Eyelids flutter with heavy lethargy, head bobs, catches itself on the verge of the abyss. Then, the call comes. Decision passed down the chain of command. And tedium turns to terror in a flash.

Entering the cubicle, the subject penetrates the bowels of a video game or wakeful nightmare. The gamer feels no accountability, trigger-happy, content to be the hand that wipes the splotches on the screen, *pulls the weeds before they overrun the lawn*. The other subject hesitates, feels the urge to question the voice of command, spends sleepless nights, ears ringing, body shaken by uncontrollable tremors.

The subject may be tall or short, stocky or muscular, it's of no consequence. On the other side of the screen, the ocean, the planet, the subject loses its subjective personhood, becomes perfectly anonymous. Concealed in nebulous concepts of duty and nation.

The subject is vantage point. The subject is malleable. A perpetual operator that brutes the living. Future blood in the sky.

The subject is the vigil, not the deviation. Now and then the subject turns, loosens the room, takes a stand at the console. Eyes need to be kept busy, exacting. Hands searching for some equivalence, a reason to keep being active, a material manifestation of data.

Laborious in task and time is the continual encounter between the subject and the dead-to-be. An embodied subjection to being the hand that disembodies. A painfully, tediously slow disconnection from time that always ends in rapid fire.

Sometimes the subject gets chewed up by regulations. Gets reprimanded for some small infraction, refracted outside the zone of what is permitted. Sometimes the grip of cold metal is unbearable, sometimes tolerance is a luxury.

Inside the cubicle, all is tedium, all is timeless, as one hour turns to two turns to six turns to twelve. Screaming would be tedious if still possible, decisions would be tedious if they could still be made. The cubicle is an abyss in which the subject is left dangling on a long chain at the end of which, in some misty distance, stands the flashing grip of command.

Entering the game, the subject is trigger. Entering the nightmare, the subject is sensory overload, cold sweat and jittery limbs, overtaxed eyes and unpredictable bowels, tremors in the chest and hands. Entering the game, the subject feels a sweet relinquishment of physical ties, becomes the weightless release of virtual action. Entering the nightmare, the subject is all physicality, overrun by a body that can't be ignored or supressed.

Nebulous behind a screen of big-brother protection, the subject becomes the consequence of duty and nation, while the planet loses its subjective concepts.

The subject is a perpetual point in the sky. Malleable, the subject operates the living, a brute future.

The subject vigils over other subjects qualified as deviations. In the loose turn of data, there are no hands to console, no materials to take a stand, no eyes to exact reasons.

The laboured hand subjects to time, tasked in the hope or pain of a future dead encounter. Meanwhile, time disconnects, disembodies.

Regulated, the subject is permitted the luxury of deadly metal. A zone where all is sensed into senselessness.

Inside tedium, the subject loses command of decisions, of the possible, of distance. The subject, reduced to a grip held over the abyss or the end.

In the virtual bowels of the screen, the subject overloads. Relinquishes ties to a body, the suppression of action. Whether nightgame or daygame, the trigger is subject.

The subject is consequence, the subject is nebulous, the screen of duty and nation.

Turned loose in the sky, an exacting force subjects the subject into making targets out of grey zones. As the brute material of the living labours into data.

Regulated, sensed, and documented, time turns deadly. Hand connects to trigger, body encounters metal.

Any one end supresses another end and so every end triggers another end, a cycle so laboured and abyssal, it verges on tedious. A game not of cat and mouse but of subject body and virtual image.

Overlord or smokescreen, occasionally the nation relinquishes ties to some of its subjects.

The subject is document, the subject is data. The subject handles the encounter to its virtual absence.

Occasion on the verge of. Banishment, disappearance, end.

As the subject, slowly, deliberately, goes up in smoke.

Subject to its own end.

We are currently on the compound and last-known location of our group ... No movement here at this time. We will keep you updated.

Copy.

Roger. Two vehicles appear to be moving south to the left. Are they staying close to the green zone or are they moving out into the open?

Broken Radio Chatter

We are now tracking three vehicles and standby. We will give you an update.

Copy.

Yeah those vehicles are bad.

There appears to be unlawful personnel in the back. Over.

Broken Radio Comms

Gonna take missile power off.

Copy.

Verify the missile is on the left and coded.

Radio Static

It is on the left and we're coded and set for the left first.

CLASSIFIED

Looks like they want us to move now. I'll tell Slasher that we got retasked.

Broken Radio Comms

That dismounted individual is now meeting up with another individual who came out of the compound.

Roger, say again. Over.

Radio Static

Thinking about the situation, I'm pretty sure we are covered.

CLASSIFIED
CLASSIFIED

Demonstration of hostile intent and tactical manoeuvring.

Copy that.

Request permission to sparkle if they can't get eyes on the coords.

We are going to hold on containment fires and try to attempt PID. We would really like to take out those trucks.

Copy that. Break, break, Slasher, we passed you coords for the vehicle on the west side of the river. Again, you have multiple dismounts in the open break.

Does he have a weapon?

Can't tell yet.

CLASSIFIED
CLASSIFIED

See if you can zoom in on that guy, 'cause he's kind of …

What did he just leave there?

Is that a *expletive* rifle?

Can't really tell, but it does look like an object.

I was hoping we could make a rifle out, never mind.

The only way I've ever been able to see a rifle is if they move them around, when they're holding them or slinging them across their shoulders.

Radio Static

Radio Static

Screener said at least one child near SUV.

Bull*expletive deleted* ... Where?!

Expletive deleted, still, I don't think they have kids out at this hour, I know they're shady but come on.

At least one child ... Really? That means he's guilty.

Well maybe a teenager but I haven't seen anything that looked that short, granted they're all grouped up here, but ...

CLASSIFIED

CLASSIFIED

Understand we are clear to engage.

Okay, he's clear to engage. I'm going to spin our missiles up as well.

Roger that.

Okay.

CLASSIFIED

Looks like they're surrendering. They're not running.

(unintelligible)

Confirm, uh, those were hits on the vehicles you were watching.

That is affirm, that is, uh, three good hits on all three of our vehicles. We are still tracking.

(unintelligible)

I'm going to zoom in on the rear vehicle again real quick. It looks ... it looks like there's a bunch of people just hanging out.

They're trying to *expletive* surrender, right?

That's what it looks like to me.

Yeah. I think that's what they're doing.

Broken Radio Comms

Uh, exiting from that vehicle was probably about 4 personnel. Believe possibly 2 of those, maybe 3, were female.

What are those? They were in the middle vehicle.

Women and children.

Radio Static

Looks like a kid.

Yeah. The one waving the flag.

Roger that.

CLASSIFIED

CLASSIFIED

Good copy on that. Uh, be advised we do have what
looks to be 3 women and 2 children possibly trying to
surrender to the west of the engagement zone at this
time.

Roger and confirm they are moving away from that
site.

Uh, that's a negative. They seem to be staying
stationary.

3 women and children just 20 metres to the west of
the second vehicle.

And that is affirm. Since the engagement we have not
been able to PID any weapons.

END OF TRANSCRIPTION

track *n.* a course of action or conduct; a
way of proceeding

If

At street level, we displayed signs of unrest

We sought justifications that had been lost or misplaced, even misunderstood

At street level, we hoped to be vindicated for our future revolutions

But when the clock struck noon, we lost our bearings

Though we kept moaning for a while longer

If we stood before a precipice, we were anathema

If decadent, we were destructive

If decaying, a nuisance

If we fed on flashing screens and neons, we were feral

If we fumbled with the lock, we pre-empted a history

If we came and kept coming, we became the clash of continental plates,

 the deafening murmur of a thousand voices

At eye level, we were volatile, full of demands and antecedents

At eye level, we waned scientific, spoke in discourses and legalese, feigned
an air of being on the inside, in the know

But in our vulnerable flesh, we were troubled, out of focus

The vast regions of our profound unknowing made our skin itch and our
palms sweat

So when the sky went dark in mid-afternoon and our shadows all but
vanished, we let out a prolonged, terrifying scream

If we lingered, it was because we needed to go on somehow

If we emptied, it was because we had nothing else to give but our insides

If we built new temples, we used fleeting ideas that easily slipped through
 the fingers and dissipated

If uncontrollable, we were put in a yoke

If days were wanton, they were not injurious to our violent outbursts

If exponentially invasive, we knew that the end was near

At our feet, a wreckage, a beached concept

We sought the sentient now, a knotted present, a wild recovery of sentiment

On our feet, it mattered that we resisted, looked for signs

But when the time came to decipher, we became infantile

Parasites who'd lost their sense of _____

If across the void, shrieks and oars slapped the water

If off-world, we thought we could be pardoned for our violations but we were off the mark

If we entertained, the parody in our mouths tasted of sulphur, alcohol, and irony

If words were our burden and proof, they were our distraction and absolution

If ultimately we were fodder, we were _____

In time, we were consigned to history and its many versions

A faint sun glowed through the haze as we smiled our sardonic smiles

In utterance, we wanted telling

Daily we reminded ourselves that we didn't matter and daily struggled to be
the reverse

In being, we wanted to exist in a grey zone, a permeable fissure, in animal
communication and comprehension

If sinking in the mud, we became a ridiculed gesture

If mobile, we reconfigured

If the elements reversed, they briefly stopped us in our tracks

If stopped, we dared to risk, grab the ligaments of chance

If we knew our species to be corrupt, we hoped that it may yet be salvageable

That on rare occasions, we'd feel a storm rise up inside another and respond

**On Origins
(a radio drama with interference)**

you might have spoken up earlier said something about it accepted the part you played in

```
CAST   IMMIGRATION OFFICER
       INTERPRETER
       ASYLUM SEEKER
```

SCENE 1: INT. IMMIGRATION OFFICE — DAY

SOUND: CHAIRS SCRAPING AGAINST CONCRETE FLOOR. QUICK
 SHUFFLING OF PAPERS. CLEARING THE THROAT.
 CLICK OF A RECORDER BEING TURNED ON.

OFFICER: (SLOW BUT FIRM) Let's begin with language, the
 inhabitants' speech where you lived, its name.

INTERPRETER: The language where you're from, the owners of
 the tribe, what do they call it?

SEEKER: I'm part of the [] people.

INTERPRETER: The [] tribe.

OFFICER: No, I'm not asking about ethnicity but about
 language. What is the name of the language
 that the inhabitants speak?

INTERPRETER: No, we're not asking about a tribe but about
 what language your people speak. What name do
 they give it?

SEEKER: [], it's called [].

INTERPRETER: [].

OFFICER: Okay, but do they call it by another name?

INTERPRETER: Do you know any other versions of it?

alarm made a phone call quietly complained exercised some caution you might have alr

have admitted some culpability yawned frowned simpered you might have sounded the

```
SEEKER:        (SOMEWHAT CONFUSED) You mean other dialects?

INTERPRETER:   No, other names for the language.

SEEKER:        (A BIT NERVOUS) I only know [ ].

INTERPRETER:   Only knows [ ].

OFFICER:       What about [ ]? Have you ever heard the people
               refer to it as [ ]?

INTERPRETER:   What about [ ]? Ever heard it being called by
               that name?

SEEKER:        No, I don't think so.

INTERPRETER:   Never heard of it.

OFFICER:       And what about [ ]?

INTERPRETER:   How about [ ]?

SEEKER:        No.

OFFICER:       (WITH EXTRA EMPHASIS) You see, the people who
               live there call their language [ ] or [ ], not
               [ ]!

SOUND:         BODY MOVING IN A CHAIR MAKING IT CREAK. FOOT
               TAPPING NERVOUSLY ON FLOOR.

SEEKER:        (HESITANTLY) I only know of [ ].

INTERPRETER:   The applicant knows only [ ].
```

nds colleagues a passing stranger said red instead of blue and almost talked yourself into

SOUND: PAPERS BEING SHUFFLED. CLEARING THE THROAT.
 CLICK OF A FAN BEING TURNED ON, ITS LOW
 WHIRRING HUM NOW PROVIDING A CONSTANT
 BACKGROUND NOISE.

OFFICER: Okay, let's talk about where you lived. Can
 you tell me the names of the countries that
 border your province?

INTERPRETER: What are the countries around the area you
 come from called?

SEEKER: You mean other countries around my country,
 []?

INTERPRETER: The applicant is asking for clarification.
 Other countries around country []?

OFFICER: (IMPATIENTLY) No, the countries around your
 province, the province you come from.

INTERPRETER: No, we want to know about the countries near
 your province, the province of your tribe.
 What are their names?

SEEKER: Well, there are other provinces near my
 province. There is province [] and []. But I
 only know of one country, [].

INTERPRETER: Country [].

OFFICER: Any other countries, other states?

INTERPRETER: Any other states around your region?

SOUND: WHIRRING HUM OF FAN GETS MOMENTARILY LOUDER.

SEEKER: There is province [] and [], as I said.

INTERPRETER: [] and [].

OFFICER: (IRRITATED) Those are provinces. I want to
 know the names of other countries.

INTERPRETER: The officer is not asking about provinces but
 about other countries that border yours.

SEEKER: (EMBARRASSED) I don't know any other besides
 [].

SOUND: CLICK OF RECORDER BEING TURNED OFF.

OFFICER: (OFF MIKE, TO INTERPRETER) How is the
 communication going?

INTERPRETER: (OFF MIKE, TO OFFICER) Well. The applicant
 speaks [] very well, in fact too well for
 someone from []. The applicant speaks [],
 which is classical [].

OFFICER: (OFF MIKE, TO INTERPRETER) Do people from
 [] not speak []?

INTERPRETER: (OFF MIKE, TO OFFICER) Well, I'm not sure.

SOUND: CLICK OF RECORDER BEING TURNED ON.

OFFICER: Can you tell me the names of some rivers that
 run through your province?

INTERPRETER: What are some rivers that run through your
 state?

SEEKER: The largest waterway that flows through the
 country is called []. A smaller river called
 [] forks off from the main one.

INTERPRETER: Two rivers, the [] and the [].

OFFICER: Are those their official names or the names
 the locals give them?

INTERPRETER: Do these rivers have other official names?

SOUND: BODY READJUSTING ITS POSITION IN A CHAIR,
 MAKING IT CREAK.

SEEKER: I only know them by those names.

INTERPRETER: The applicant doesn't know any other name.

OFFICER: (HOT ON MIKE) Okay, let's move on. Tell me
 about the circumstances that brought you here.
 Describe your account as concretely as
 possible, in chronological order. Include
 dates and names.

INTERPRETER: So to continue, tell us about how you came
 here. Tell your story plainly and in the right
 order of events, describing people and dates.

SEEKER: The conflict in the region began years ago
 over a disputed area of land. The main
 religious leaders had tried to come to an
 understanding but had failed.

INTERPRETER: The conflict began a long time ago over a land
 dispute that religious leaders had...

OFFICER: (TOP) We are cognizant of the general situation
 and history. Just tell me your story.

INTERPRETER: We know about the overall situation and history
 of the region. Focus on your own story.

SEEKER: (FATIGUED BUT TRYING TO BE CLEAR) On [],
 armed men raided my town [] looking for
 rebels, so we fled. When some of us arrived in
 [], we were afraid of both the militiamen and
 the rebels.

SOUND: A FAINT YET DISTINCT CLANGING CAN BE HEARD,
 LIKE STEAM TRAPPED IN THE PIPES OF AN OLD
 RADIATOR.

INTERPRETER: We left on [], when armed men entered town []
 searching for rebels. We got to town [],
 fearing the militia and the rebels.

OFFICER: Who is "we"?

INTERPRETER: And who is "we"?

SEEKER: Everyone who wasn't fighting, everyone who
 lived there.

SOUND: ANOTHER CLANG, SOMEWHAT LOUDER.

INTERPRETER: All those not involved in the conflict.

OFFICER: Okay, please continue.

INTERPRETER: Go on.

SEEKER: On [], I woke to gunshots in the night. A great light was coming in from the outside; the sky had an orange glow. Part of the town was on fire. Some of us tried to run, but we were stopped. We thought they were rebels but they turned out to be militiamen. They took us to their post.

INTERPRETER: One night, he was woken by gunshots and fire outside. He tried to run but was stopped, along with some others, by soldiers, who took them to their headquarters.

OFFICER: How many soldiers were there? Did they ask you for identification?

INTERPRETER: How many militiamen were present? Did you need to identify yourself?

SOUND: ANOTHER SERIES OF LOUD RADIATOR CLANGS.

SEEKER: (STARTLED BUT TRYING TO FOCUS) Uh, there were six. They took me to their post and threw me in a cell. Then one came in and started beating me. He broke my arm. He made me lie on the ground and stepped on my back. He said he'll shoot me if I move. He said, "You're all rebels. We're going to kill you all."

INTERPRETER: Six soldiers took him and put him in a cell. One beat him up and broke his arm, walked on him. The soldier threatened to shoot and...

OFFICER: (TOP) Okay, I don't need to hear all he said. The broad strokes will do.

INTERPRETER: Just give us the main outline. We don't need to hear all he said, word for word.

SEEKER: (QUIETLY, SOMEWHAT DEFEATED) They put us in a van.

INTERPRETER: They put him in a truck with some others.

OFFICER: Who were the others?

SOUND: THE CLANGING CONTINUES. SOUND OF LIQUID BEING SLURPED.

INTERPRETER: Who were the other people in the van?

SEEKER: I didn't know them. They took us to camp []. I was held for six months. During this time, I was interrogated many times, assaulted, and tortured. But I won't go into the details because you said you didn't want to hear them.

INTERPRETER: He didn't know the others. After they took them to camp [], he was held for six months, questioned, beaten, tortured, but he won't discuss the details.

SOUND: PAPERS BEING SHUFFLED.

OFFICER: Okay, let's move on. Tell me about your journey here.

INTERPRETER: Now tell us about how you came here.

SEEKER: I was in []. With two other friends, we drove overnight to [].

do not justify the means claimed obsolescence you might have done all you could to help

```
INTERPRETER:   With two friends, he drove from [ ] to [ ] one
               night.

SOUND:         CLICK OF RECORDER BEING TURNED OFF.

OFFICER:       (OFF MIKE, TO INTERPRETER) Can you drive in
               one night from [ ] to [ ]?

INTERPRETER:   (OFF MIKE, TO OFFICER) Hmm, [ ] and [ ] are
               far. I don't think you can drive the distance
               in a day.

SOUND:         CLICK OF RECORDER BEING TURNED ON.

OFFICER:       What happened next?

INTERPRETER:   What did you do next?

SEEKER:        We had to wait several days, then we boarded a
               train. It took three days to get to [ ]. It
               was hard to sleep during that time because
               there weren't enough seats and we had to take
               turns.

INTERPRETER:   After a few days, they took a train to [ ].
               The journey lasted three days, and they hardly
               slept.

OFFICER:       Was it because you were anxious or too excited
               to sleep?

SOUND:         SOUND OF LIQUID BEING SLURPED.

INTERPRETER:   Were you too excited or nervous to sleep?
```

lines given up something even the most insignificant trifle waivered mumbled responded a

SEEKER: (CONFUSED) Like I said, we didn't have much
 room. The train was packed and we had to take
 turns sitting.

INTERPRETER: They had to take turns because the train was
 crowded.

OFFICER: What happened after you got to []?

INTERPRETER: What happened next?

SOUND: ANOTHER CLANG.

SEEKER: We went to the airport and boarded a plane and
 flew to []. One of my friends had a vague
 acquaintance in [], so we rested there for a
 few days. Then he drove us close to the
 border, and we crossed the border on foot at
 night. Then we walked for several days, mostly
 at night, until we arrived here. And that was
 the end of my journey.

INTERPRETER: From [], they flew to [], where they stayed
 with a friend for several nights. He drove
 them to the border, which they crossed on foot
 at night. Then they walked for a few more days
 until they got here, and that was the end of
 their trip.

SOUND: A SERIES OF CLANGS, BURSTS, A SPUTTER, THEN
 NOTHING.

 THE END

liner notes

track *n.* a rough path, especially one
beaten by use

Trackscapes

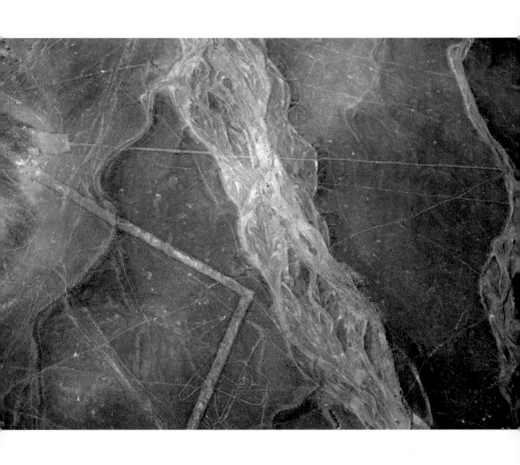

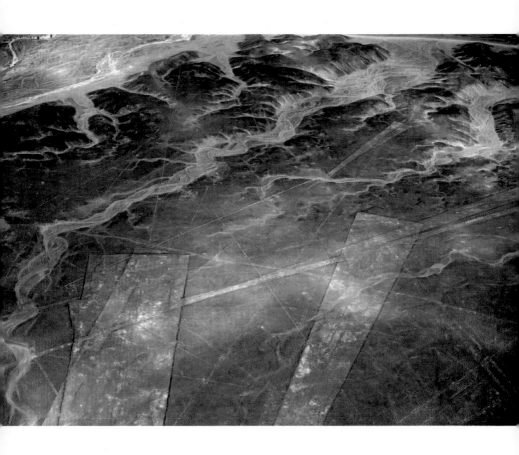

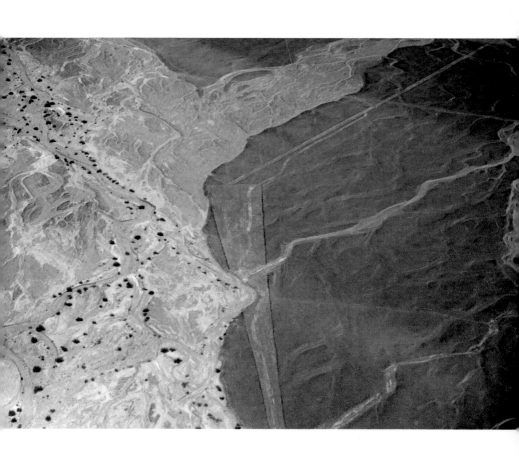

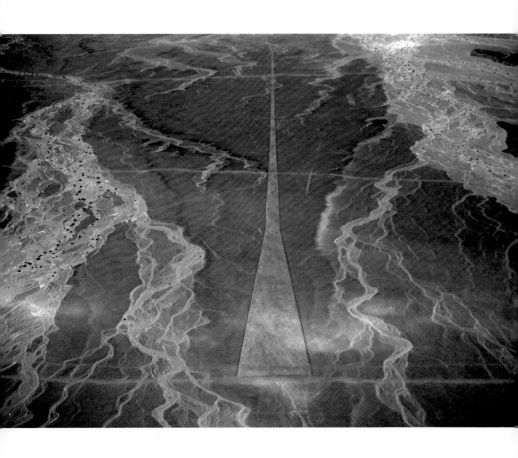

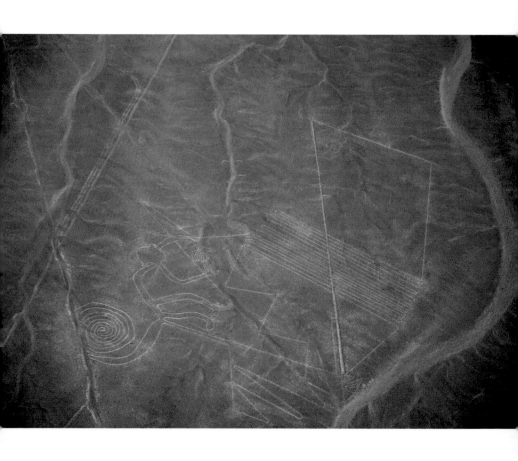

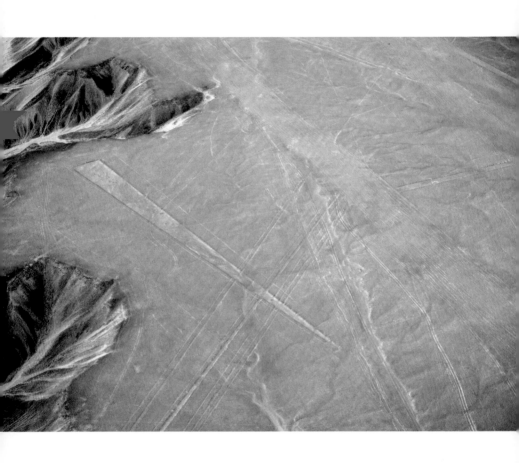

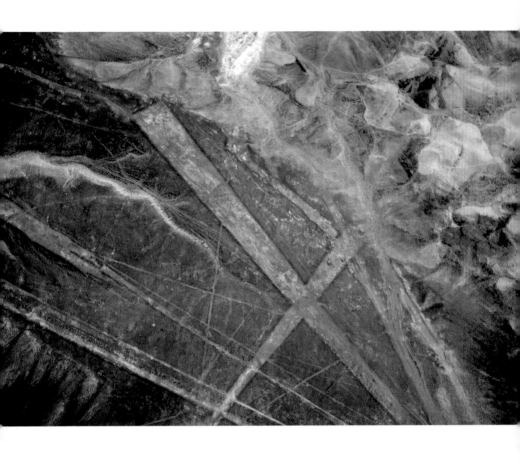

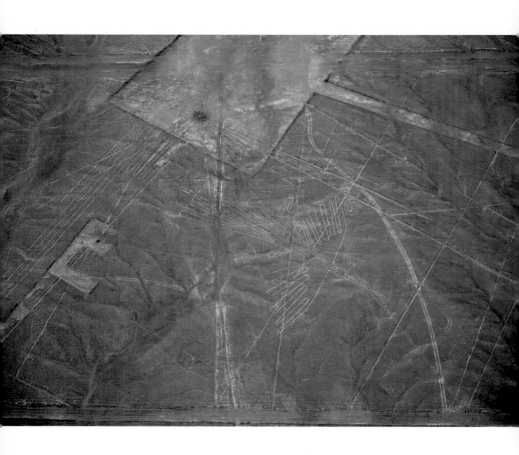

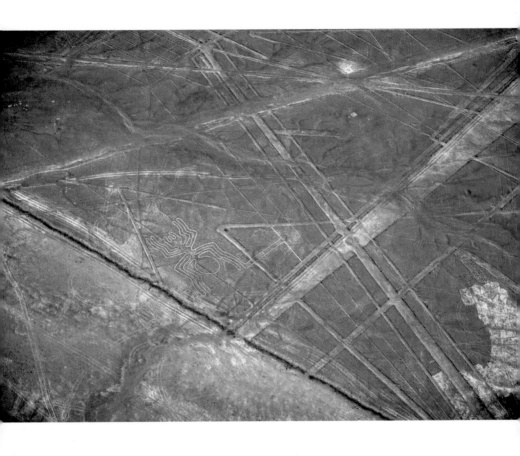

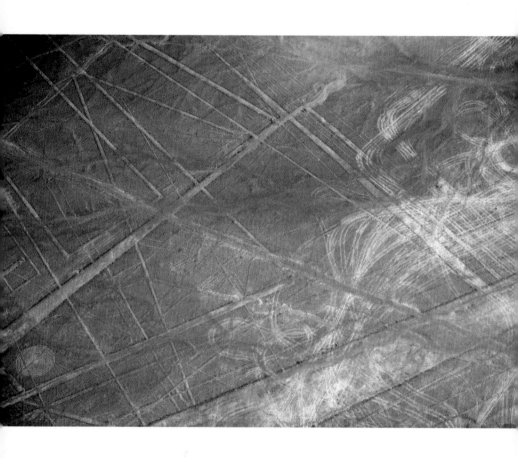

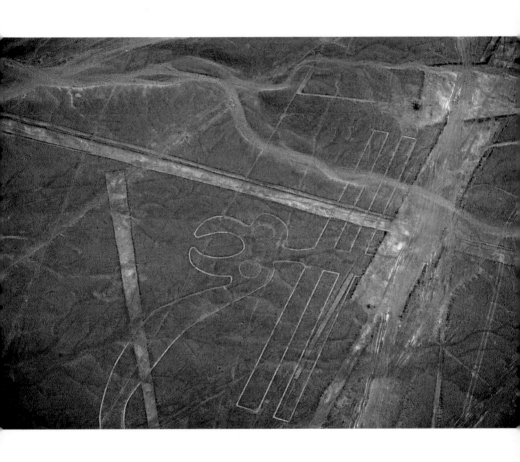

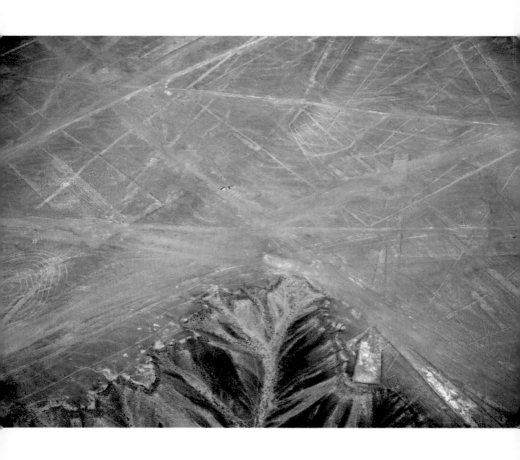

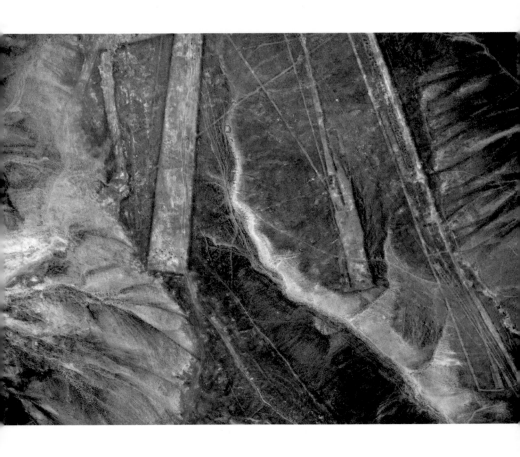

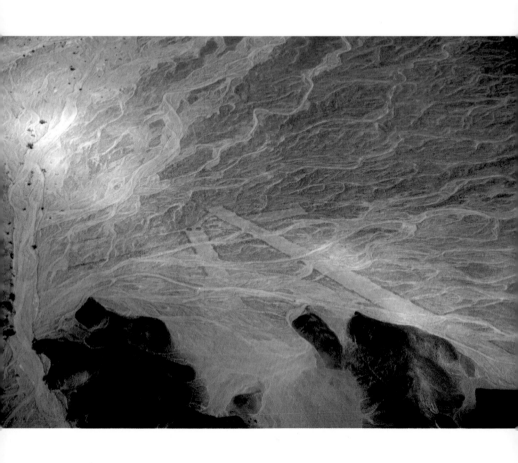

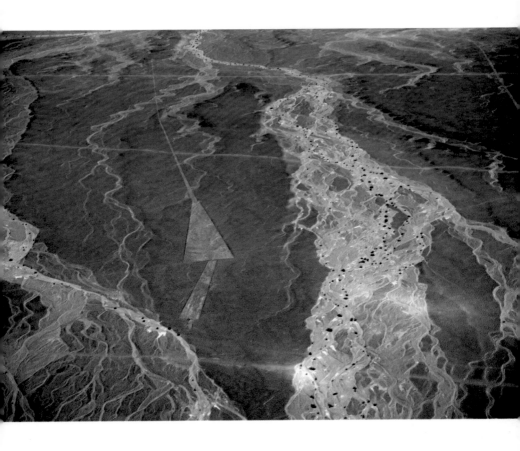

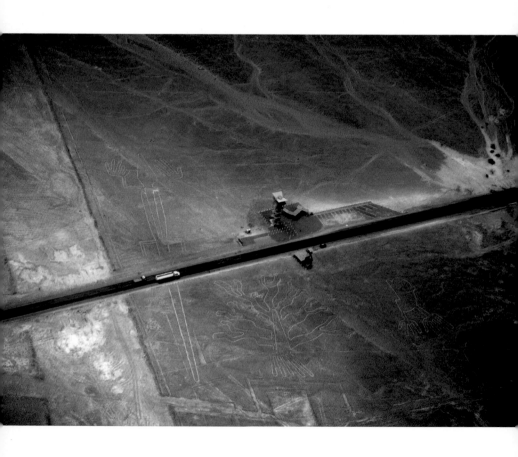

track *n.* a mark or marks left by a person, animal, or thing in passing

Tracking Animal
(a survival + *tracker's marginalia***)**

If
others instinct the auto of my animal,
an "I" bios.

If at a juncture,
the animal is not automaton, not biographic yet
faceted here in the written, a set of signs, a howling,
belonging to its own metonymy.

the tracking hand is fine and
oval, a fine specimen, inclined
to excess yet executed with
precision. alongside, cursive
marginalia linger languorous,
decadent notes

"Anima automatic biologue"
 incantatory or
the subject of the animal justly

"Anima ought to be graphed"

choral odes, paragraphi
insert the scribe

 between *Homo* and animal
fronting or finite, I render animal: animal in sense,
animal in material, animal on the shore of itself,
animal yet undefined, a lasting animal derived,
defending in debris for its own definite.

animal promethean for what it tends, rubs in
motions, motives; animus positing prowess from
the promontory. This promised animal natures
tactile in elevating our domesticated tongues
(delete ~~discipline~~).

breathings,
accents, and
elisions
frequented by
symbolic
commas

 Deepening in temperature, deepening so long
in temperate, deepening in time, and for what
rests in coming, we soar passing the promise of
this animal on the shore of itself.

 Deepening in temperament, does the animal
 regain us?

 Animal squall?

 silence regained/reined in
animal

Sharing the told animal known before another
animate lunging to a sort of animaling
 regarded/guarded instance/
 insistence to anime

 estrangely animated

Lunging lacerated, known in the singular sign, the
animal is not verily known.

 acknowledging anima pivots not
on a sound

yet inseparable
 from the pitch
 of our configuration

The animal, doggedly, is not known because
 we know it.

Because it knows
without existing in knowing, the animal signs,
veers, though made voiceless, keeps voicing its
own knowing.

 animal scratches
 solitudes

 animal seers
 multitudes

An animal relates me.

Here our vista will
recognize a great precarious and anti-cautious
text surrounding the animal.

rare are
explanatory notes,
rare the soundings
of dissenting
fragments

don animaling gifts/tales/tusks.

Contralto, intone your terror
and recognize the animalized facility to vocalize
morphemes and phonemes.

imparting
to animal companions and compatriots

animal tenor

the dramatis personae
are scattered here and
there. thus the habitat
is voiced, discourse
and quest enacted

curt penned animals

So in commencing to animadvert the relation to a
face, a seeing

 possibly a calque of questions will transmit an
animal view. Prodded. Justly?

 Liminal question:
Does our dilated animation revoke the pelted
pace of the animal?

Animal reels teeming with animal.

Letters counter, question the animal. Question the animated answer, enjambed from a litter, a word's reality.

again marooned in "anim-"
genre or rule

unplaced
fragments,
miscellany,
a corrupt
passage

Tracking and being after soars not the solipsistic/
solitary question appealing to my animal.

and if animated

I press against animal
I repress animal

evoke animate consume

 Progenitor
in sense (forcing not the biblical or Greco-Latin
tradition) deviate a saying I. Prone or pest to the
animal? In what pressing order?

 Gnawing all cases, if appetizing, the
animal victuals (incantatory animated word is a
coming witness). Animal in victim, in prey, in
deviant – I fellow its lot.

 occasionally, the worm-
 eaten words require
 only some ornamental
 amplification. yet some
 passages so mutilated,
 the lacunae invite
 corruption, margins
 most objectionable

pressing quills into animal call

animistic quell evoking its lot

impressing quills into "animal" call, for example, "shot."

Foisted on / Feasted upon in divergent localities and saturated through divergent registers animals the passionate being, my passion of the animal, my animal passion for another.

 inevitably we must demand what arrives in the fraternity of femina when animals enter the scene. Or invert the animate arrival when at feasts.

 Quandary:
Animal's arrival or arrive animate?

"animal" regard abysmal limit

 animal regard
 infants close to an apocalypse

next, we have a puzzling
passage, vestiges of nouns
and verbs, insufficient clues
as to action of elision

 if from the directive "impressing quills into
'animal' call, for example, 'shot,'" I sublimate the
call and guillotine of a citation.

Here the "you" of the
"animal" call is neutered before the "I," a fiction
splayed out on this imaginative tableau, sorting,
classifying taxonomies of beastly perspectives.

 situations of
knowing animated treatises of
philosophic anima

reflected animals seek animistic seek
 animal regard

 furtively animalistic

 animal
poverty
 action is wanted,
 but its truth is
 "animal" call *improbable*

 an-
 abundance

While discourse,
profoundly licked and fortified, does not address
in passing, does not avail, does not regard naked
before animaddress.

the theoretical animal
the clairvoyant animal animates regard

 vast before
the animal without being vast

address the animaddress

"animal" call " " *seems to have been*
 the sense of this verse and
anima all *the next*

 anim al
solitary (a myth)

 an(non)imal(ous) calling cries

 Original animaling citation numbered and
located (sourced).

 mammalian number

animubject

 animal voids
that is to say animal domesticates

a radical confusion
possessed the copyist

command the animals by naming them

divide the animals by naming them

convoke animavail

 if intending to dominate, domesticate,
dress the animals within if the authority
of the animated act is held in suspension

 we, falsely liberal in our magnanimity
of animal naming

 animal over

the rear has been
changed to the front,
or entangled in
strange opposition

 nameful and nameless the

 anima voids

 is apparent animus

 the vestiges of
 -al quantifiable *phonemes confine*
 the vestiges of the
 animal's tracks

 passing between hound and
 animaw is vertiginous

 divinatory before the neutered animal regard

They (that is to say, I) suspended their (that is to say, my) compassion, deprived the animal of its manifest, its manifesting, the meme of experience, langue-neutered. Disputing original animaling citation to mark an instant.

requisite is the ready for the nature of animality
imperative of
the verb

the essence of

animality

crave/count on some encircling of animal
overtness?

nature of nascent animality
mutinous in the wounded word

nature

within mal and maw a fatality

Comment, pose, question
in passing the animal regard and citation deprived
of experiential access as told.

truant in animal regard
a ballsy meditation

 latent mawing
lacerations fallen falling

 subject to / master over
this natural mal while

animal hones, stores, sires, gestates property of
anim(vit)ality

the name criers, animated, avert the shot

 My animal passion veils *subtly present is*
the age. *also the trace of a*
 second hand

 known before the anomaly

 animal deviant?
animal reproach? animal regard? animal avowal?

Descry. The machinic animatends us.

year to year to anime

naming the animal admits and remits a
difficulty

animal tempo *the marginal note,*
as usual, devious

animalbeing as example

history of the philosophical animal, philanima

Does the animal chimera
an animal soiled with animal? Does this pluralize
the animal? Or sovereign its animal chemistry
chimerical?

Animalsquall – a mutt!

Yet they (that is to say, I) appeal to the
institutions of mouthing animal.

The mutation of experience
continues to perturb the maw of anima appeal.

innocuous animal report

*could this entire
segment be merely
a dittography? the
traces of ink,
perhaps accidental?
after all, the entire
premise is doubtful*

regard vivacious in anim(vit)ality

overturn history in the animal
report, the being-with of the habitat that spells
a-n-i-m-a-l

singpluranimal

animal sacrifice of biblical or Greek or Egyptian
antiquity

animal treason

animal experimentation

formulas of animal treatment
endlessly programmed and propagated

modern methodology transforming animal
vivacity into leering object

industrialization of elementary production of
viable animal

as per animal reduction

unprecedented proportions of this asubjecting of
the animal

human animal sovereign over animal protection

genociding the
animal genius

animal proper thus exterminated

over survival, over peoplement

industrial, *imitate the sound*

mechanical, chemical, hormonal, genetic *of someone*

violence that subjugates anim(vit)ality *smelling a feast*

mastering

animal mortality

animal drone

a harsh, grating
sound indicated by
the context

the osseous

problematic of the anima

animates the question, its form

so animale

voices appear to be sound,
though originally omitted

sound the

mal of maw

breach thesis

surrounding animal, animal logos-primated

decisively question the suffering

sentence of animals

Common and afaced, radical finitude partaken
with animals, the moral of vitality's finitude,
compassionately experienced and taken
vulnerable in angst.

here, the restoration
remains problematical
and a further defect is
disclosed at the beginning

certain anima impairment

allege anima suffering sensate

animal the versed vitality

animal regard known before another

decade

decadent with the autobiographical animal

with animal entrails

animal aggrandizement

*here, one annotator
would substitute while
another would restore*

abyss between the

singular-plural animal appellation

animals appeal

the contiguous continuity
of entrails schemas between hind appellation and
animal appeal

naming hounds the animal

appellation

1. Abyssal rupture draws the unilinear and indivisible line between two borders, the hounded and the animal in general.

2.

these ink marks, these scanty vestiges may be read as " " or " "

3.

in lieu of "animal"

or "anim(vit)ality"

tender the anime
a species or genre of animal meaning, animal in general deems "animal"

the redundant " " is an evident simplification

provokes

"animal"

common as rational animal, common as political animal, common as conversant animal

proficient in the dominant anima subject

yet denied animality

Valued hypotheses and theses surround the
animated maw, the mutt anim-.
 animalsquall – a mutt! *the lacuna is strained to*
 animalmotto hounds *the utmost, while the*
 noisy, compound bodies
 seem post-classical

a soiled concept: the animal (dissected)

a boasted territory: the animal (interrogated)

 private animal
lingo

 solo animal voicing

 a mutt dance: the animal
 affinity

Does the animal I fellow problematize?

a parlance, a frond? animal this primal question:
"Does the animal I fellow problematize?"

 treasoning the animal's
animality (solicited)

 my auditory animal concedes
communicates a system of signage

 The fiction of demanding, "Does the animal I
fellow problematize?"

 The it, the has been, the could be of anima

 moth-eaten animalistic signs portent
a sort of signature, Brailled, traced, effaced

(example of animal) (hounded for example)

though the wording of this
passage is elusive, the
sounds of hunters are
evident. to amend or restore
would prove too precarious

 trace then erase

animal and the hounded

 feigned entrance of the mutt assembly
doggedly follows the "animal" and the "just"

as though the general "animal" communes the
non-humane, the common sense, the "common
link," "animal" qualities abyssal in their liminal
animated structures

deign to animate vast camps
 define the animaled article

biographical zoo of the _____
anima

in the lair, a riddle, a
device that cannot be
taken as instrumental

"autobiographical animal"

historical

animal, conceptual human animal

consecrate the question of the

vital animal

rationed animal

quantifiable animal

the amnesia of most philo-interpretive
routes leading to *my* animals

a vestige of ink suggests
a circumspect accent

In parting, my animated figures accumulate

the recurrence of derivatives is
rather curious and the speaker
even more questionable

I draw animated figures. Animals othered in
fables

the metamorphosis of the animated figure

gnaws on the anima

language
animimetic

sorting through all the animal tautologies in philo-

draw animal guard

animals are my guardians

a sign animes, maws

ineffective summons for
ordinary orthography

In parting, I draw animated notes

 philosophical
animality of anim-

To fawn over a certain appeal of my animals

I obligate an intersection of the animalistic
and the autobiographic

the animutt?

the corrector's hand is
unintelligible

vindicate

the animality of habitat

the animal

horde memories my woods

enter the vegetal
rapacious

animal
anima

animal treatment on a par with a tongue *a question mark may
have disappeared at
the end of the line*

hide-and-seek of the animated

elegant problematic of the animal makes a scene,
ruminates in silence the animal-machine
 assembles soul in the animachine
 lector of the animated creature

 whether singular or
 plural, passive or
 active, the third
 person is present and
 cannot be excluded
 on metrical grounds

But animachine errs famished
 animal neglect

animal subject

 animal capable of grasping the silenced
anima (the captive), a quasi-animal, quelled,
derives a silenced anima

teeths the animated species

 animutt?

defiling the animal lyre
multiple animutts encore into suffering

dire questioning of the animated limit between
animal and habitat

will we soar, protest, counter the generalized
singular of *animal*? be not indifferent but
differentiate in animal sensibility.

searing limit between general animal and
general habitat

Animal generalized in the animal singular.
vindicate, an animal habitability

*the simplest
explanation is
perhaps the
right position*

animal lament

 from bestiary to bestiality, "my"
animal junctures, aleatory

 animate

attribution of properties

 *what was originally
 proclaimed in place of*
"animal" *" " is doubtful*
indicates "my" voice

 forging another mutt from "animal"

contravening limbs *animutt*

 animutt exceeds species, genre, individuals,
vivacious and mortal in multiple, a hybrid
monster

animals daring the animutt

donning animal plurality

owing to a hole in the transcript, the
hand and the reading are uncertain.
ditto the dramatis personae

I flow, we surflow, I track, we muster, I dare
animal. chimerical animal wind

mated choreography
anime density

 a mal oscillation
animal dimension, elevation, sedimentation

 animal sacrificing its meme

 animal sacrificing its invention
 its anima- *exiguous traces of a*
 mutilated word seem
pelation *to arouse discomfort*
 in readers

 sacrificing

its animated consequence

 yet grave and determined
is the animal apparition

 animate scar

these traces submit to animal offering

refuse
the animal as an offering

words: wounds of animal prey

 sacrificing animal lector
 animaling remorse

in a moment's deluge, a historical anima emerges

hounding insistence regards the animus

 taunts the animal

trial of a situation or species stomachs the animal,
the animal others

disgorging/discussing anima

animal
dissonance or assonance: natural?

sounds animalistic resurgence

innumerable animated figurines

short, oblique
strokes, worm-
eaten, are likely
choral

derivative animal parts

animal genus
animates the possible

the only aim of restoring
this fragment would be to
offer an apparent sense and
as such, possibly mislead

animutt detours

 sovereigns the mutt in animutt

folly of the disarmed animalistic anima is chastened, chimeraed into the verbal body of the animutt:

1. I state the uneasy entente of the plural singular – animal/animals

a soiled figure of animality

separating the othered animal from habitat, reconstituted in the continual genus of animutt

general animal or animality appeals to the maw of animutt
 commune not the generalized,
categorized animal
counter not this animalistic pagination, countless animal words, the animal cruxes of these rubbings

2. The mutt in animutt is deviant

invisible liminal separation of habitat/animal

does not deter the animal

3. auxiliary animal means

animutt traces
the autobiographical animal, ventures responses

 celled in the autobio-
graphical animal

Is the bio animal the theatrical animal?
 the political
animal the compulsive animal?

 What is the sense
of the auto-animal?

the philosophical might suggest
"autobiographical animals"
 as the summary beasts of literature

though the pace may
be restored without
difficulty, line " "
is suspect and
somewhat obscure

 elegant connotations and

stamens of the anima

reflected
ani-

trove enters the mutt of utterance and
the mutt of animal

 uttered animal

 utterance, a viable animal; animality, a viable
vent

 viable animality of a wrecked imprint

how to be essence
beyond a generality of animal? how to be viable?

might the animal
trace and retrace a route to its own animalhood?

animal utterance of animutt

Can an I mount in this relation or
regard of animal naming? Should an utterance
mourn, known as common appeal to the lone
multiple of animal?

are these reflections
of a vindicated
animal narcissism?

A generated animal?

a tranquilizing of animal?
a numbing of animal?
In such muddy wordlairs animal approaches
animal.

[..]

the belonging of the lines
suddenly stops here

Bonus Track Eight over Two (a soundtrack)

semisilent.ro/eight-over-two-a-soundtrack

Liner Notes

The definitions in the liner notes were taken or adapted from the *Canadian Oxford Dictionary*, second edition, edited by Katherine Barber (Oxford University Press, 2004).

"A Study in Portraiture"

Within a four-by-nine-block grid in the vicinity of my house, in an urban neighbourhood of Montréal locally called the Plateau, approximately seventy surveillance cameras observe from fifty-eight residential and commercial buildings. This portrait series attempts to reverse the gaze, invert the panopticon.

"Trackers – Drone Operators (Slasher Screener Radio and Intercoms)"

Sourced and re-enacted from David S. Cloud, "Transcripts of U.S. Drone Attack," *Los Angeles Times*, April 8, 2011, http://documents .latimes.com/transcript-of-drone-attack/.

"On Origins (a radio drama with interference)"

To determine the national or ethnic origin of refugees who seek asylum yet lack the necessary paperwork, in other words to judge the veracity of their claims and thus decide their fates, immigration officials in many countries worldwide have resorted to a Language Analysis for the Determination of Origin (LADO), an interview that aims to trace and evaluate the seeker's language profile. While linguists advise "considerable caution" in using such analyses, LADO has become a gatekeeping tool. See in particular the University of Essex's Language & Asylum Research Group (https://www1.essex.ac.uk/larg/).

"Trackscapes"

Eyes, skin, bones. Present. Here. Blowing over the plateau from the west, a fierce evening wind slams into faces and bodies. The rickety stairs shake as I walk up the old observation tower. A blinding sun hovers low over the flat line of the horizon. As I reach the top, it happens. Awestruck. Time dilates. The contours between my body, the wind, the flat, rocky desert, the vault of the sky, and the lines blur. And crystallize all at once. I am no longer just a body, a gaze, standing apart from this environment, but within it, mingled, intertwined. The feeling is overwhelming, ecstatic, humbling.

The next morning, I'm in a six-seater plane flying low over the Lines, and the feeling is present and just as strong. I look through the camera's viewfinder, frame, and press the shutter button. Compose with a gaze that has become interior, both within and without, add another layer to the existing and reverberating palimpsest of the lines, forms, terrain, reflections of clouds and sky. Try to find a continuum between their ancient echo and the alien presence of my lens.

*

The Líneas y Geoglifos de Nasca y Palpa, or the Nasca Lines, lie in the pampa of southern Peru, an arid plain nestled between the foothills of the Andes and the coast. Created roughly between 100 BCE and 700 CE (dates vary) by the Nasca people (a name given to them by archeologists, for their language has not been preserved so it's impossible to know what they called themselves), they shape giant drawings out of the desert, tracking the contours of dry, rocky landscape over hundreds of square kilometres. At ground level, the Lines look like furrows or shallow trenches dug into the earth, only readable as lines from certain angles or hilltops. From the air, however, they coalesce and disperse into vast geoglyphs of plant and animal figures, hundreds of triangles, trapezoids, spirals, zigzags, cleared areas, and thousands of radiating rays and straight lines.

As this is one of the driest regions in the world, the natural elements have preserved the Lines over centuries, though some have been damaged by human disregard (the Carretera Panamericana cuts through them, for example). It was only in 1994 that the Líneas y Geoglifos de Nasca y Palpa were declared a UNESCO World Cultural Heritage Site. Many have speculated on their purpose, the more current thought being that they were ceremonial and related to water rituals (the Nasca left waterworks and aqueducts still used today), the cleared areas functioning as open-air temples. The wanderer Bruce Chatwin called them a "totemic map" (*The Songlines*) and poet and artist Cecilia Vicuña, a "libro desierto" or "desert book" (*A Book of the Book*).

In adding my voice/eye to those who have worked from this desert book, my intent is not to tell or document, for their story is not mine to tell. I can only visually attend to a story whose messages may have floundered in the floods and been buried in the earthquakes and wars that, by the eighth century, had decimated the Nasca. I bear presence to their abstraction, the (constantly shifting) drawings shaped by interactions between sky, environment, topography, perspective, and traces of human movement. In our world, so many meanings of *track* or *tracking* are negative, oppressive. The Líneas de Nasca stand in stark contrast to offer positive traces of human endeavour and survival. At the same time, they expose limitations of Western or Northern views and voices. They point to knowledge systems that valorize an intimate and necessary relationship to the ecosystems of the region; they trace a sense of connectedness, integrity, interconnection: an interwoven palimpsest of relationships with other people, animals, symbolic structures, the environment, and water. The lines are communal, for they required a group of people to make them, and they inspire movement and migration, necessary human acts.

The region is today part of the broader Quechua-Kichwa Territory, and the Quechua have their own history of colonization that

extends into the present. I made a concerted effort to find an Indigenous organization, community group, or Nation with whom I could speak about the region, yet no such group exists at present. The reasons as to why this may be so no doubt include the cruel effects of colonial rule that remain strong in the area. At the same time, it is important to note that Indigeneity and Indigenous Cultural Protocols are not monoliths, and there is rarely only one point of interface or approach. Also different notions of ownership are at work, ones that are more communal rather than individual, and my personal interactions with those who live there only made this all the more clear. I therefore deeply thank Pachamama, the earth through which the Líneas de Nasca entered me and upon which they continue to trace their resonances today.

"Tracking Animal (a survival + *tracker's marginalia*)"

The poem comes after Jacques Derrida's book-length essay *L'animal que donc je suis* (Paris: Éditions Galilée, Collection La philosophie en effet, 2006), while "*tracker's marginalia*" is imagined and glossed from *The Oxyrhynchus Papyri*, edited by Bernard Pyne Grenfell and Arthur Surridge Hunt (London, UK: Egypt Exploration Fund, 1898–1919), a lengthy exegesis of, among other texts, a fragment of Sophocles's play *Ichneutae* (The trackers). In the landscape of the page, a subject tracks D's "animal," follows his animal word in order to become the animal (according to the double meaning of the French word *suis* as both "being" and "following") and free the word-beast from the philosopher's argument, help it cross the porous space between tongues.

Acknowledgments

Versions or excerpts of some of the work included in *Eight Track* have previously appeared in or were commissioned by *Datableed*, *InterRe:ACT*, *Touch the Donkey*, *Lemon Hound*, *Pallaksch. Pallaksch.*, *carte blanche*, *MuseMedusa*, and *SEMI SILENT*. Thank you to the editors and curators. "Eight over Two (a soundtrack)" won a Semi Silent Award 2019, and an excerpt from "Tracking Animal" was nominated for the 2018 3Macs carte blanche Prize.

I also wish to thank the A-Frame Residency (Prince Edward County, Ontario, Canada), the Audain Visual Artist in Residence program (Simon Fraser University, Vancouver, British Columbia), and the Canada Council for the Arts for giving me time and support to create parts of this book.

A very special thank you to Gregoire Pam Dick, for everything, for constant encouragement, and especially for putting me on the tracking scent early on; to Erín Moure, for literary friendship and for being one of the book's first readers; to Stephen Collis and Jordan Abel, for editorial insights and support; to George Bowering, Carla Harryman, and Kaie Kellough, for their time and generous words; to my knowledgeable guides at Alegría Tours Perú, for allowing me to learn more about the Nasca culture and people, and to Aeronasca Perú, for enabling me to take the aerial photographs of the Líneas de Nasca; to the Talonbooks team, especially Charles Simard, Les Smith, and Kevin Williams, for making this book a reality.

Oana Avasilichioaei is a poet, translator, and multimedia artist. Distinctions include the Semi Silent Award (for the audio work "Eight over Two," 2019), the A.M. Klein Prize for Poetry (for *We, Beasts*, 2012), and the Governor General's Literary Award for Translation (for *Readopolis*, 2017). Based in Montréal, she frequently crosses borders to perform her work internationally. *Eight Track* is her sixth book of poetry. See oanalab.com.